Illustrated by
Sam Loman

Edited by Jonny Marx

Designed by Jack Clucas

Cover design by Angie Allison

With additional material adapted from www.shutterstock.com

© 2015 by Michael O'Mara Books Limited

First published in the United States in 2015 by Running Press Book Publishers
A Member of the Perseus Books Group

Books published by Running Press are available at special discounts for bulk purchases in the United States by corporations, institutions, and other organizations. For more information, please contact the Special Markets Department at the Perseus Books Group, 2300 Chestnut Street, Suite 200, Philadelphia, PA 19103, or call (800) 810-4145, ext. 5000, or e-mail special.markets@perseusbooks.com.

ISBN 978-0-7624-5988-9
Library of Congress Control Number: 2015941622

9 8 7 6 5 4 3 2 1
Digit on the right indicates the number of this printing

Running Press Book Publishers
2300 Chestnut Street, Philadelphia, PA 19103-4371

Visit us on the web! www.runningpress.com

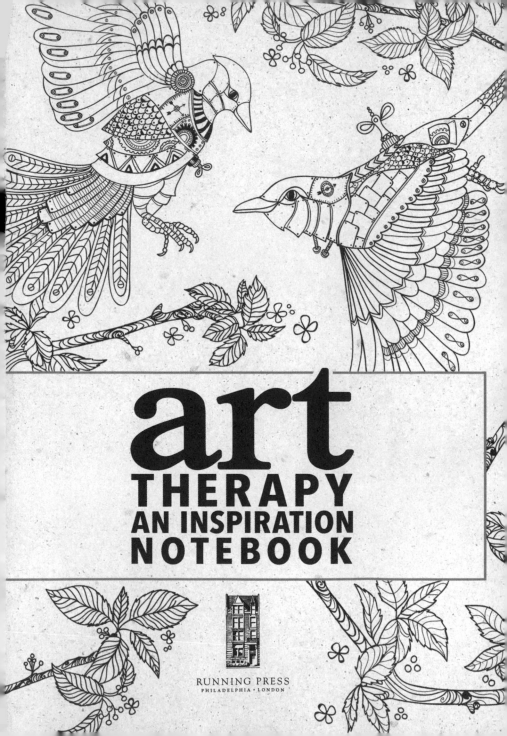

art
THERAPY
AN INSPIRATION
NOTEBOOK

RUNNING PRESS
PHILADELPHIA · LONDON

This book belongs to

This notebook will inspire you
to color, write, doodle and draw.
There are quotes to ponder and
plenty of blank spaces for you
to fill in any way you wish.

"The greater danger for most of us lies not in setting our aim too high and falling short; but in setting our aim too low, and achieving our mark."

Michelangelo

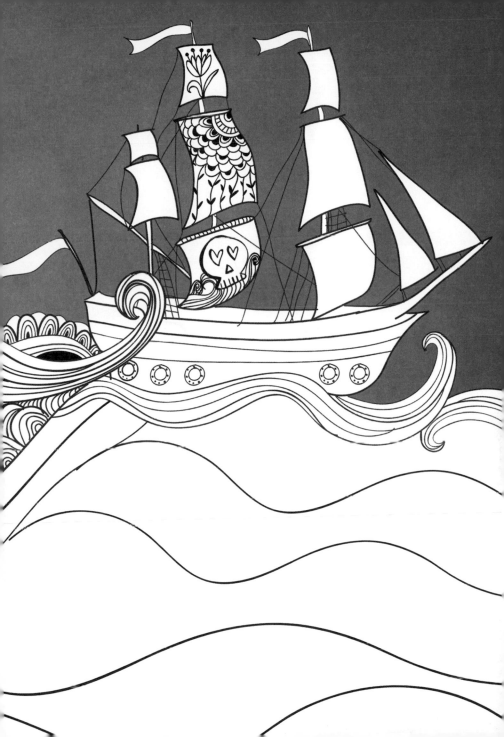

"Drawing is still basically the same as it has been since prehistoric times. It brings together man and the world. It lives through magic."

Keith Haring

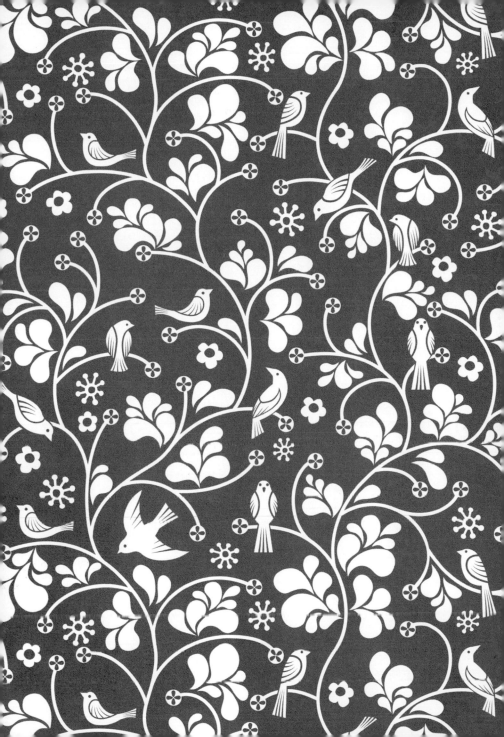

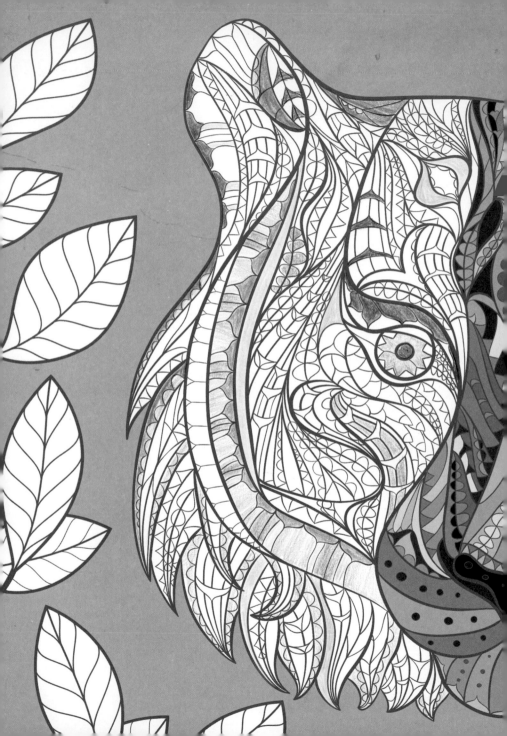

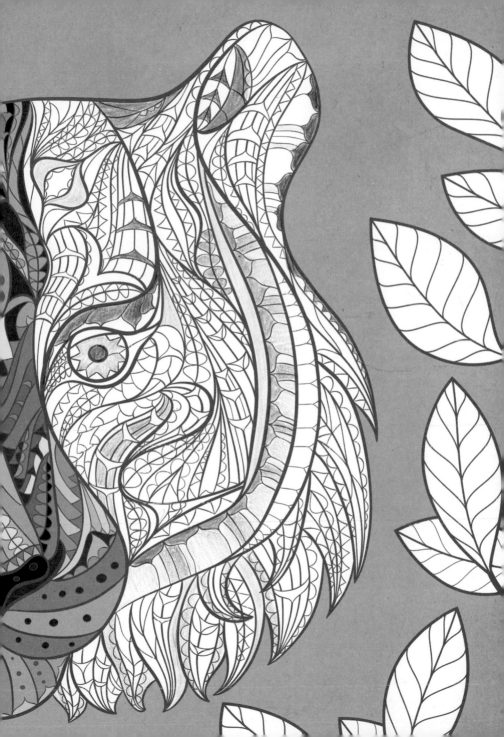

"Every portrait that is painted with feeling is a portrait of the artist, not of the sitter."

Oscar Wilde

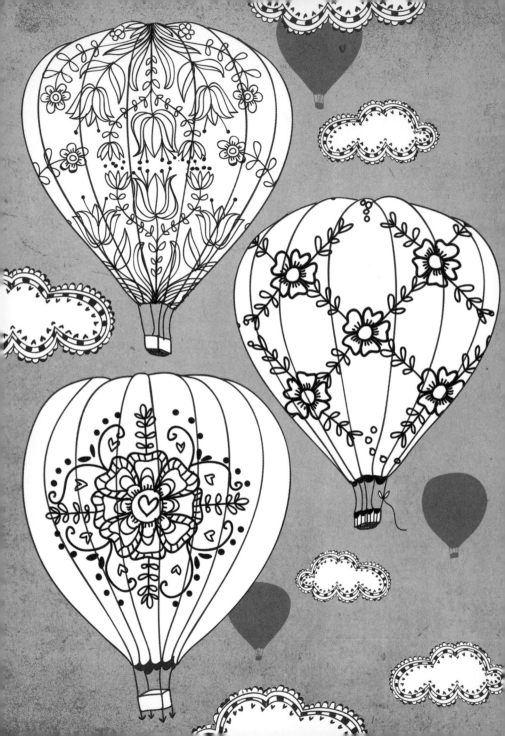

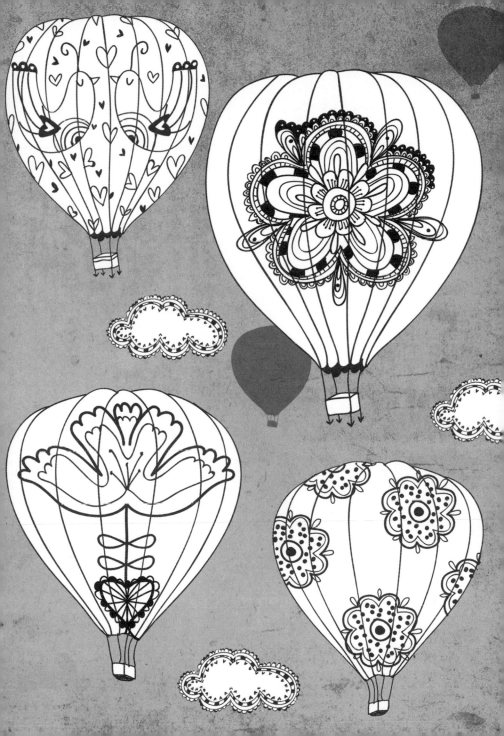

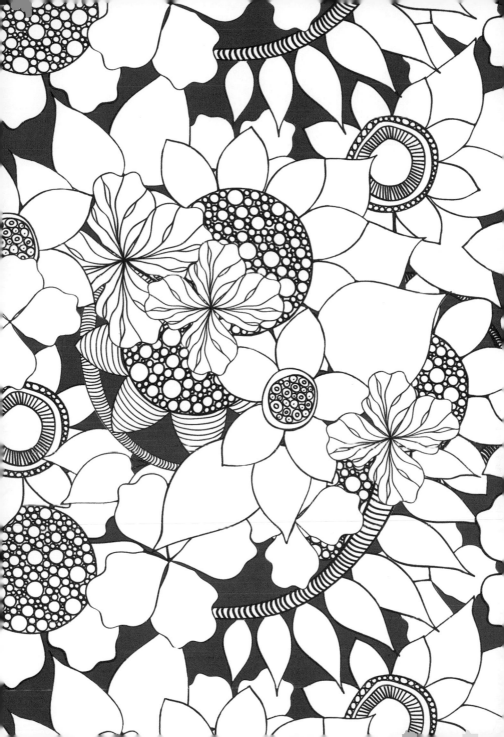

"You can't use up creativity. The more you use, the more you have."

Maya Angelou

"Works of art, in my opinion, are the
only objects in the material universe
to possess internal order…"

E. M. Forster

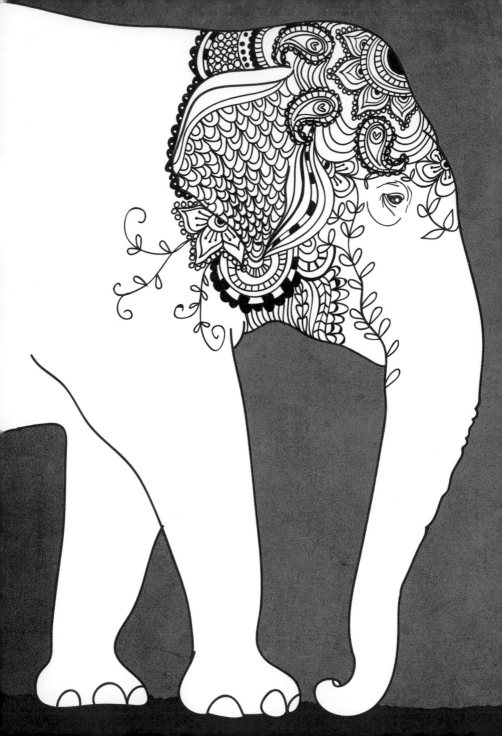

"If you want to conquer the anxiety of life,
live in the moment, live in the breath."

Amit Ray

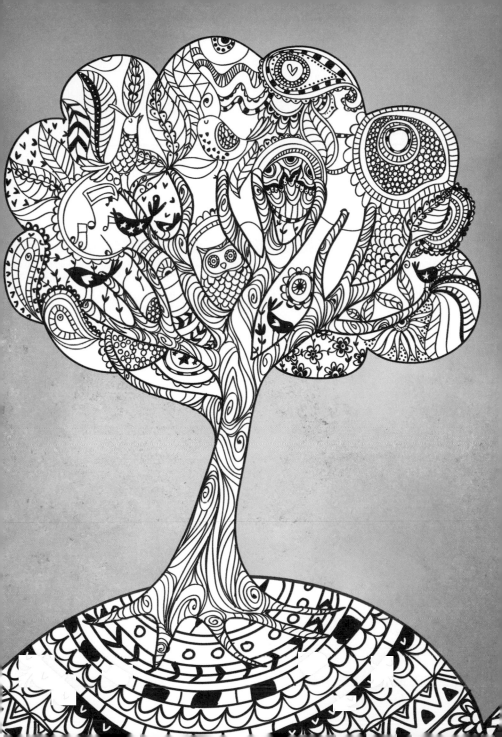

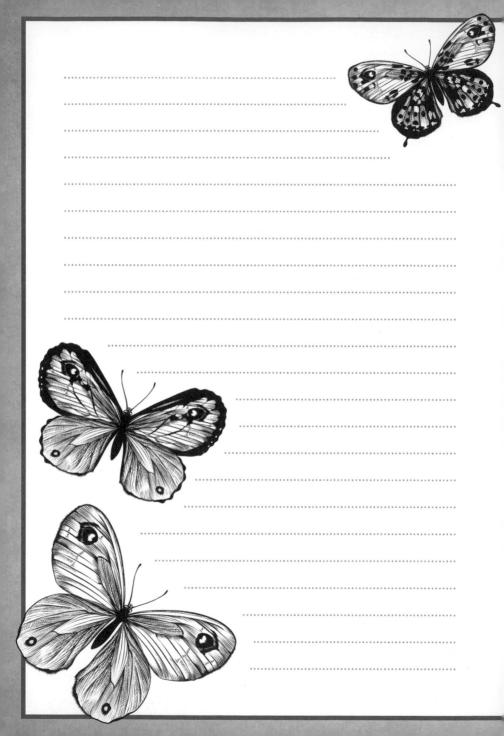

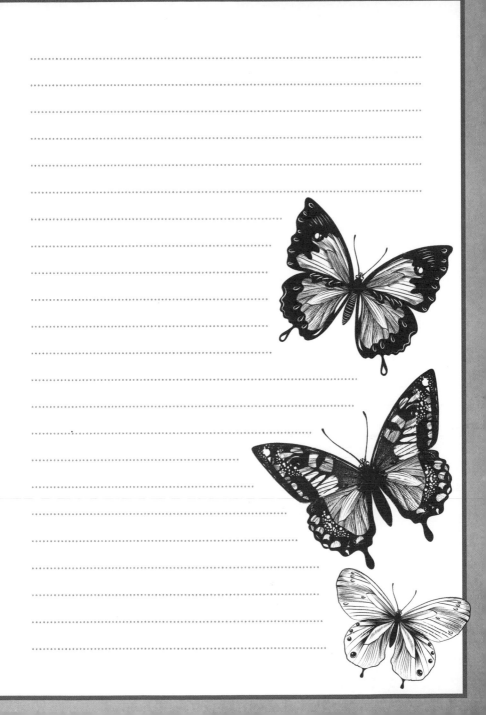

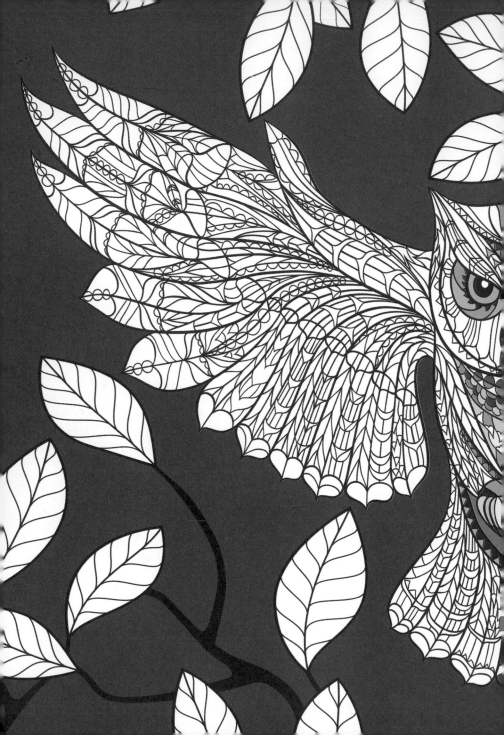

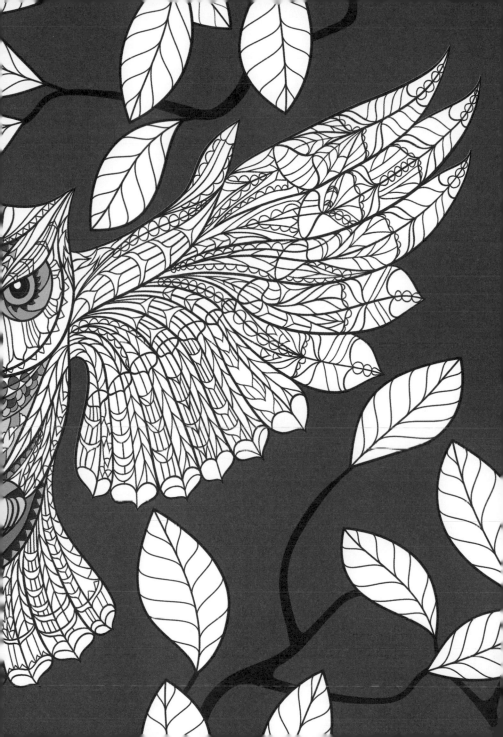

"Your skepticism will gradually diminish and your fear will turn to love … All art was modern once."

Nicholas Serota

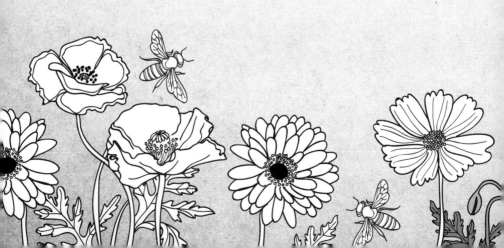

"In times of stress and adversity, it's always best to keep busy, to plow your anger and your energy into something positive."

Lee Iacocca

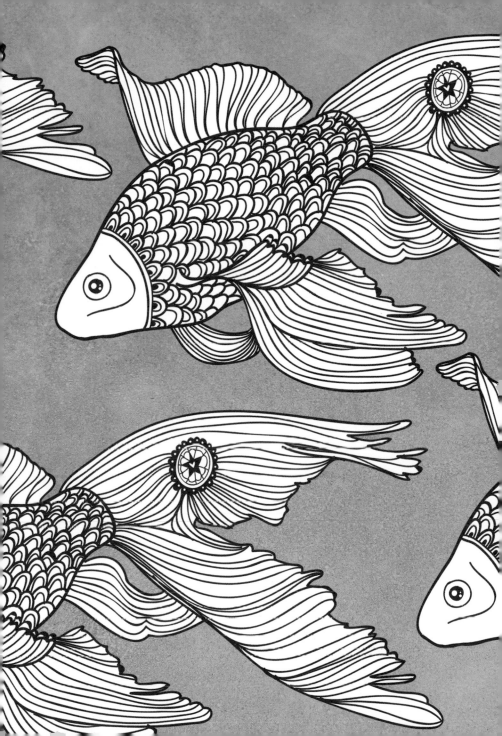

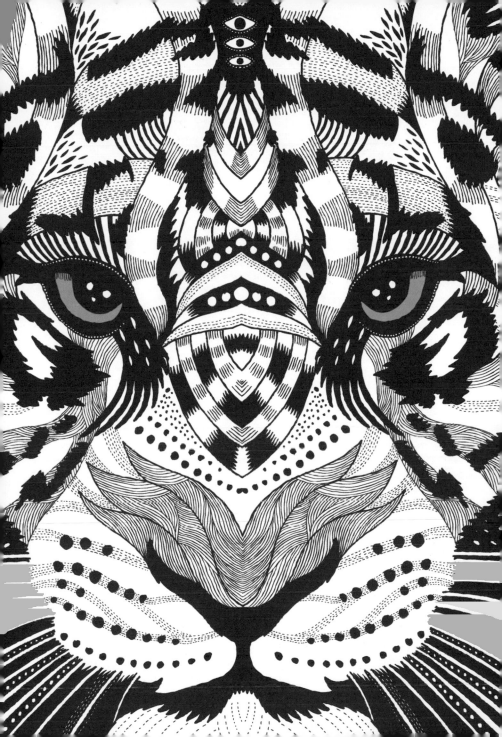

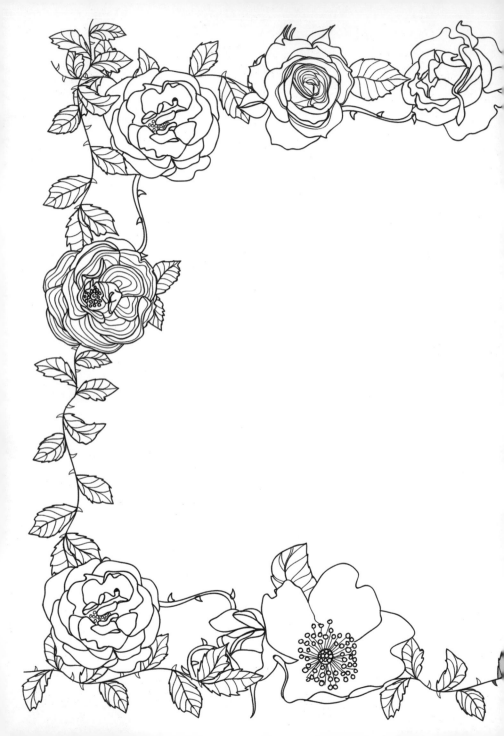

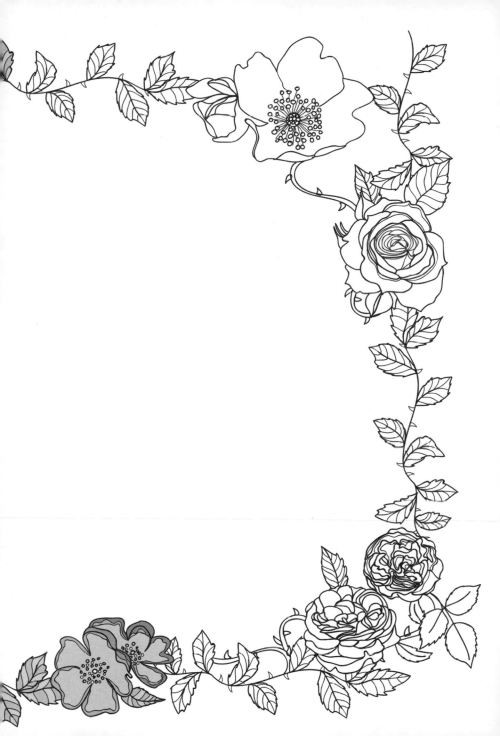

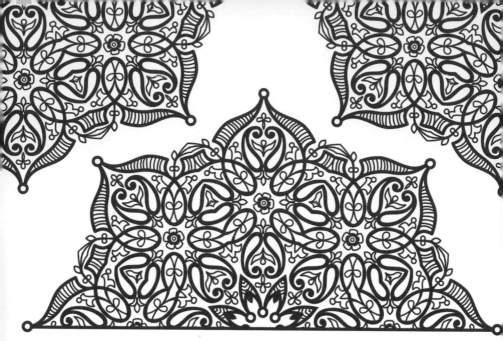

"I strove with none; for none was worth my strife;
Nature I loved, and, next to Nature, Art."

Walter Landor

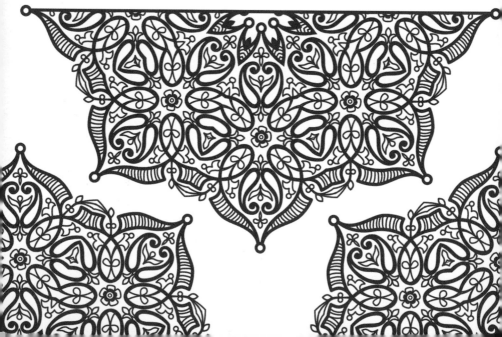

- ...
- ...
- ...
- ...
- ...
- ...
- ...
- ...
- ...
- ...
- ...
- ...
- ...
- ...
- ...
- ...
- ...

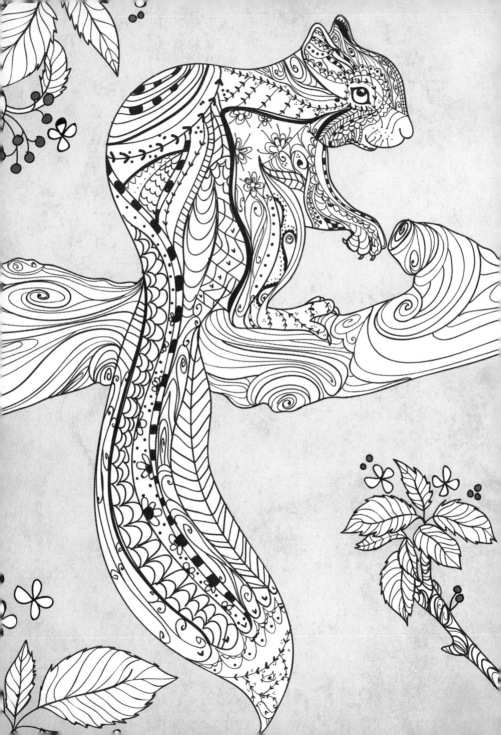

"Color seems to radiate happiness and the spirit of modern life and movement…"

Clarice Cliff

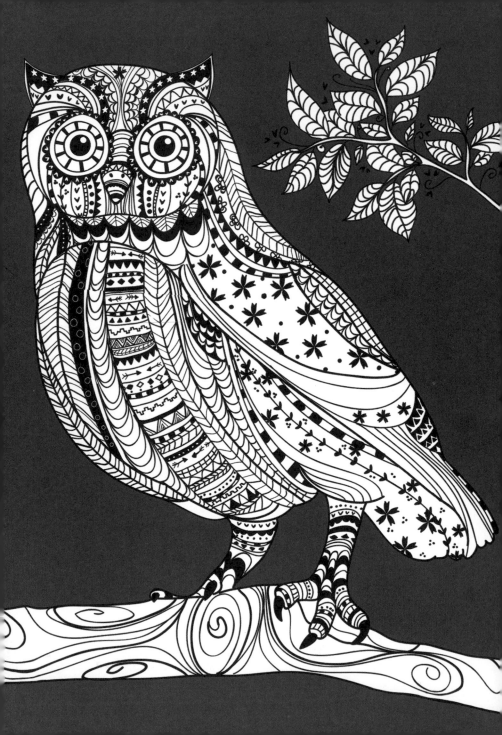

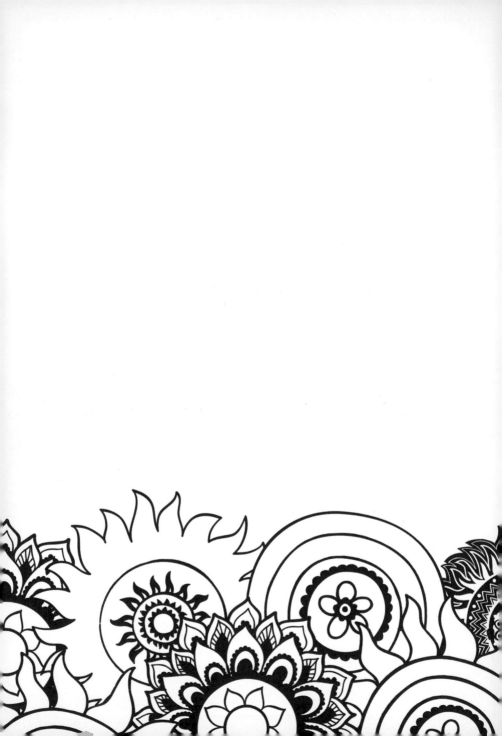

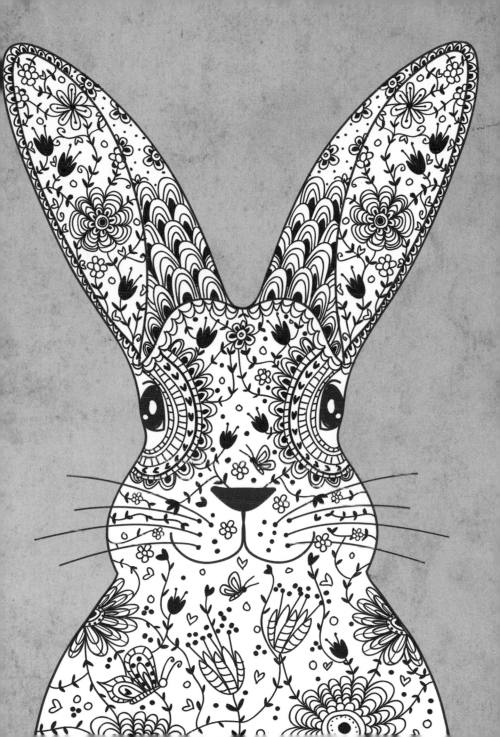

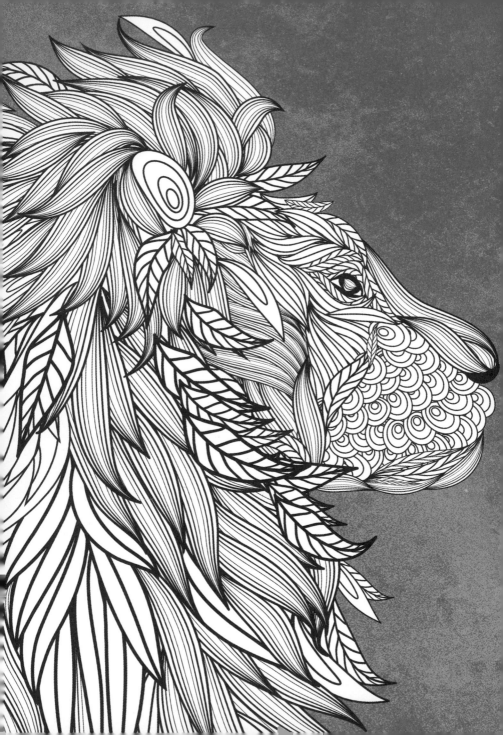

"If you are distressed by anything external, the pain is
not due to the thing itself, but to your estimate of it;
and this you have the power to revoke at any moment."

Marcus Aurelius

"A drawing is simply a line going for a walk."

Paul Klee

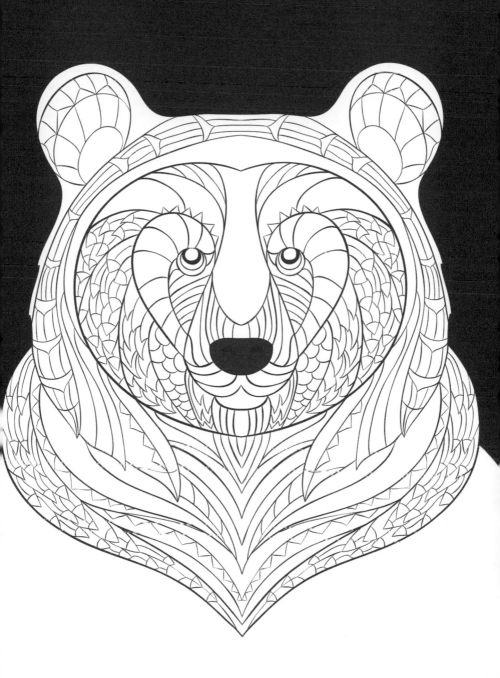

- ...
- ...
- ...
- ...
- ...
- ...
- ...
- ...
- ...
- ...
- ...
- ...
- ...
- ...
- ...
- ...

"Mindfulness is simply being aware of what is happening right now without wishing it were different; enjoying the pleasant without holding on when it changes..."

James Baraz

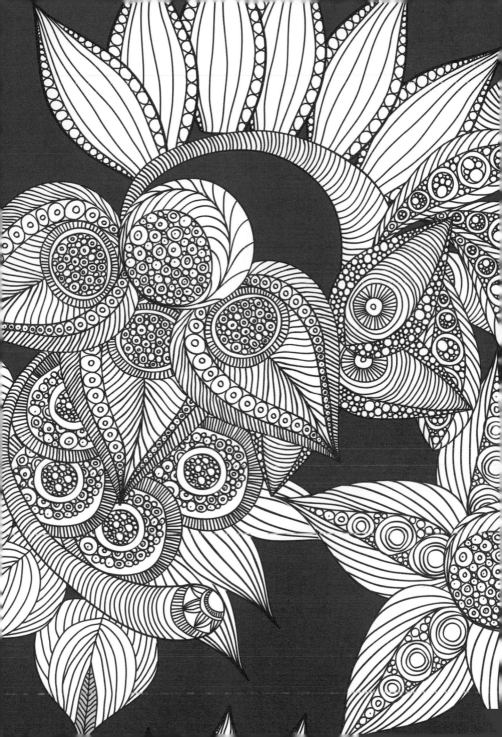

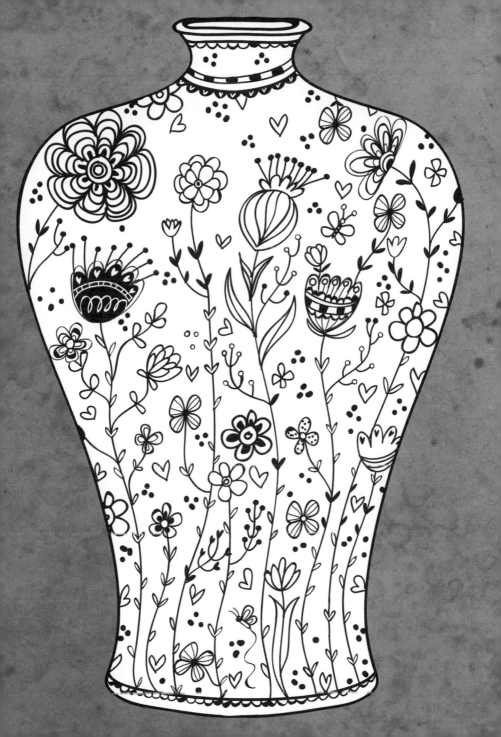

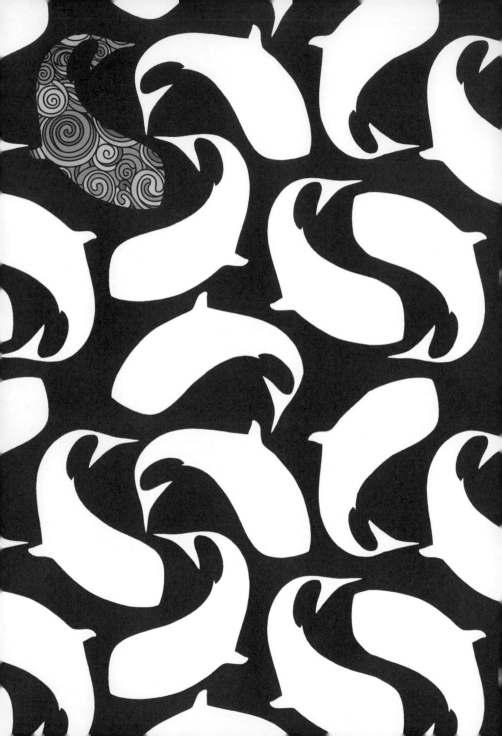

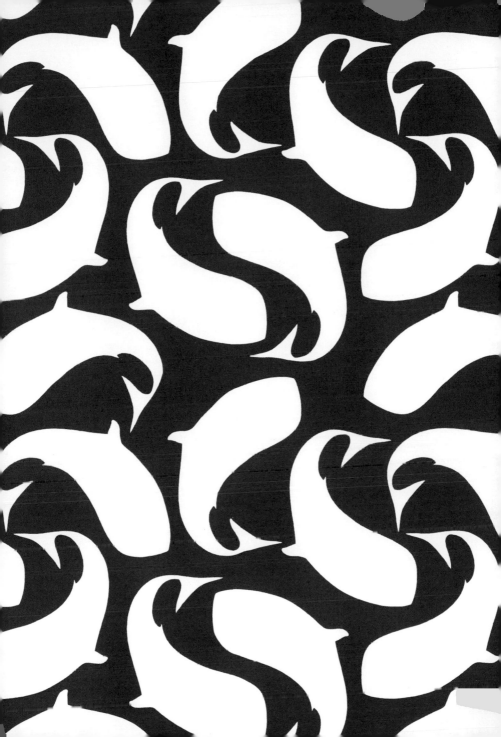

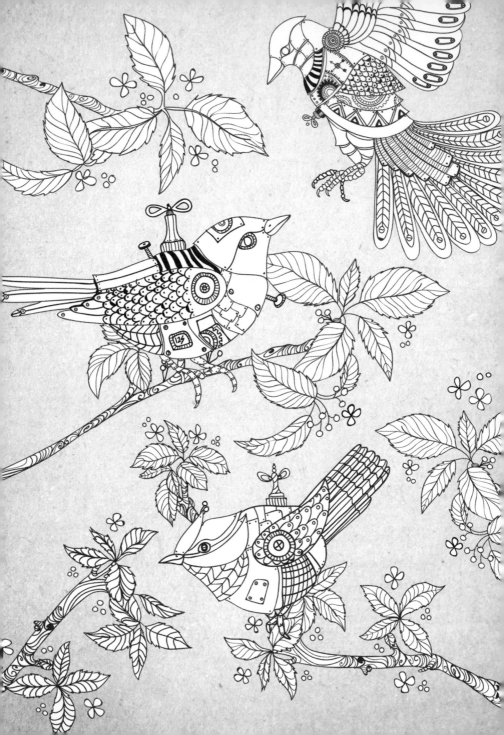

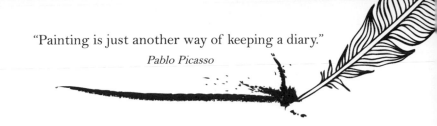

"Painting is just another way of keeping a diary."

Pablo Picasso

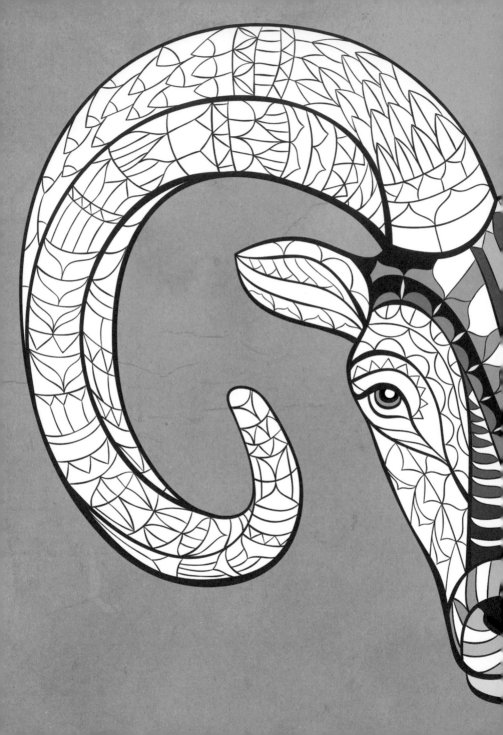

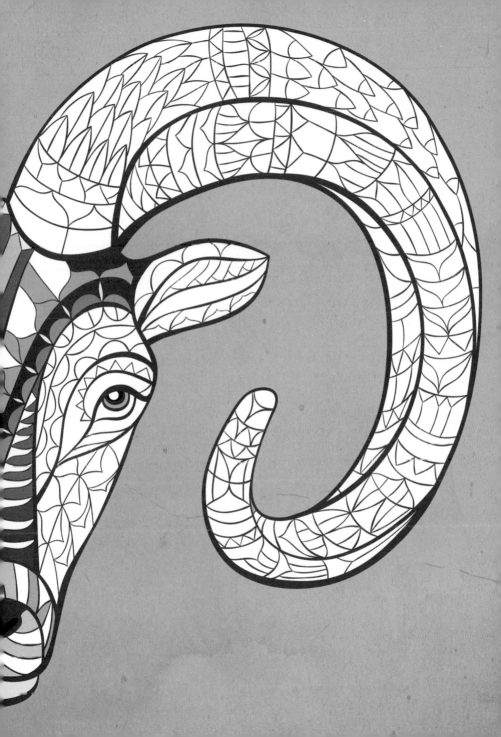

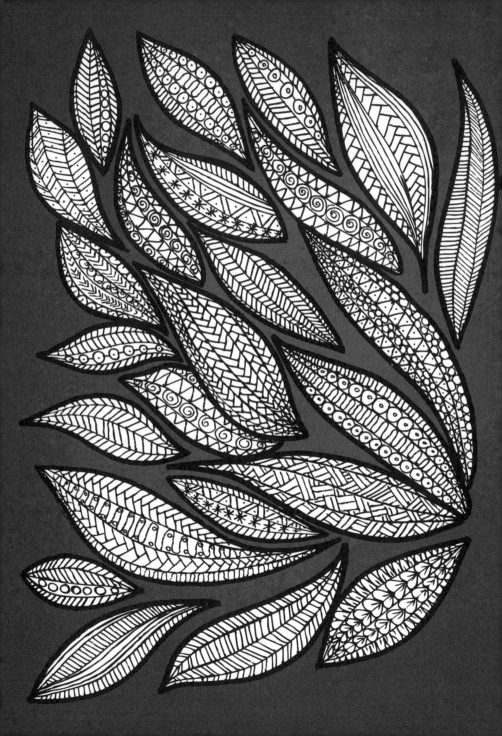

- ..
- ..
- ..
- ..
- ..
- ..
- ..
- ..
- ..
- ..
- ..
- ..
- ..
- ..
- ..
- ..

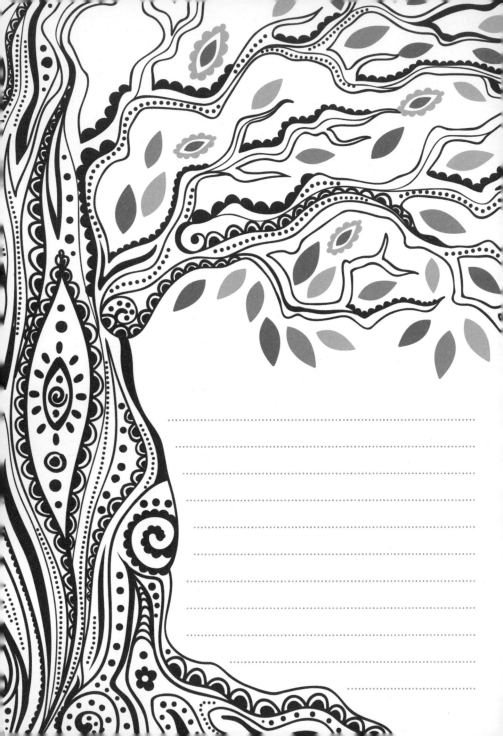

"Art is born of the observation and investigation of nature."

Cicero

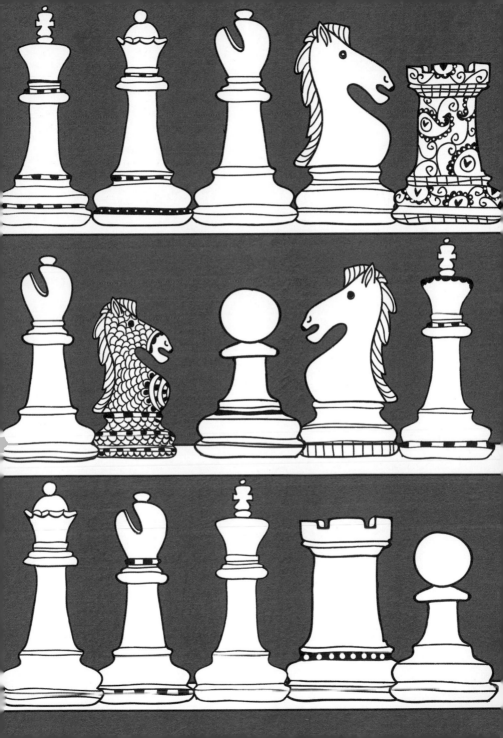

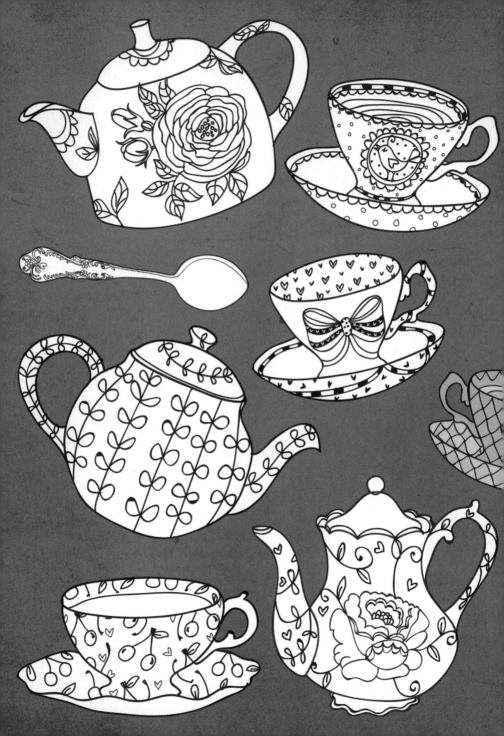

"Genius is one percent inspiration,
ninety-nine percent perspiration."

Thomas Edison

"Stress should be a powerful
driving force, not an obstacle."

Bill Phillips

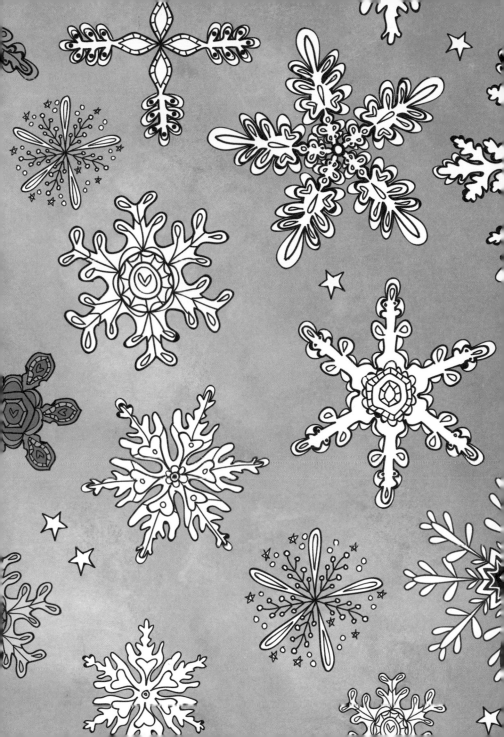

"Art has no other end, for people of feeling, than to conjure away the burden and bitterness."

Gustave Flaubert